Pride!

LGBTQ Inspirational Gay Pride Adult Coloring Book

40 one-sided
stress relieving
art therapy
coloring pages

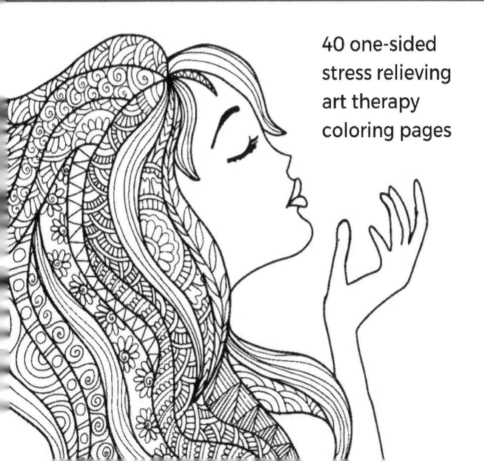

Parker Street Books is an independent publisher of adult coloring books. Enjoy our exclusive designs, and personalize them to be uniquely yours! Relieve stress and refocus with mindful coloring. Parker Street books are fun and affordable. Thanks for being a fan!

ISBN 13: 978-0-9994485-6-4

It takes courage to grow up and
become who you really are.
—e. e. cummings

I'm as gay as a daffodil, my dear.
-Freddie Mercury

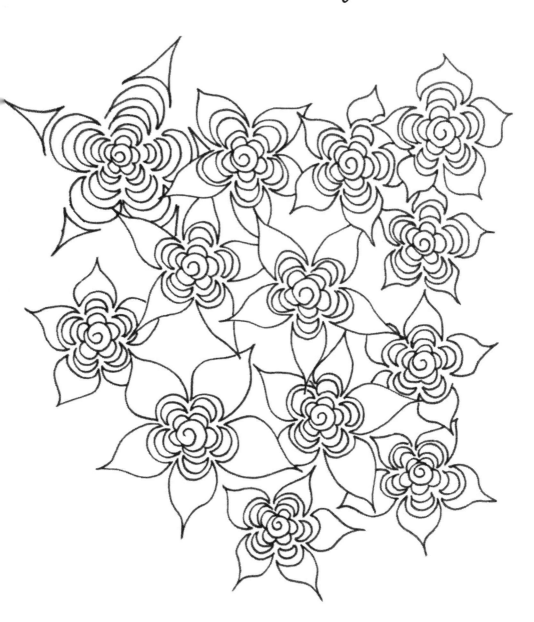

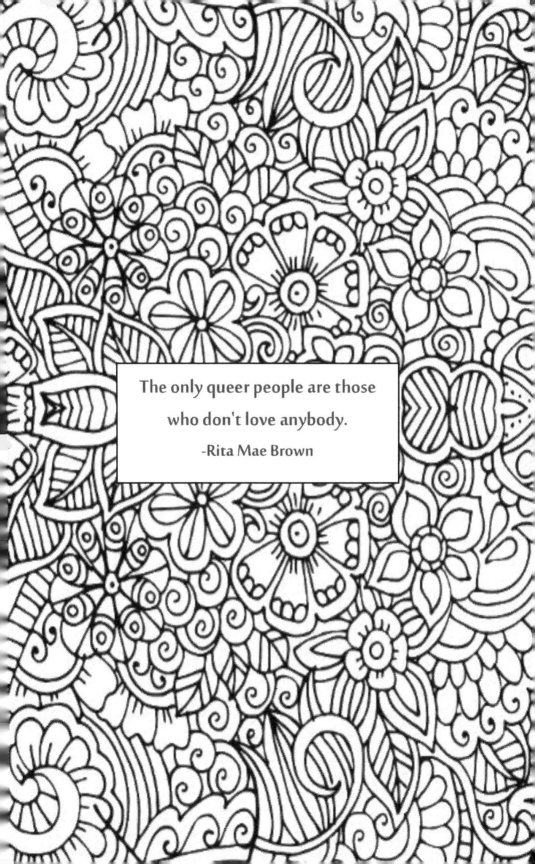

The only queer people are those
who don't love anybody.

-Rita Mae Brown

There is only one way to avoid criticism:
do nothing,
say nothing,
and be nothing.
-Aristotle

I think being gay is a blessing,
and it's something I am thankful for
every single day.
-Anderson Cooper

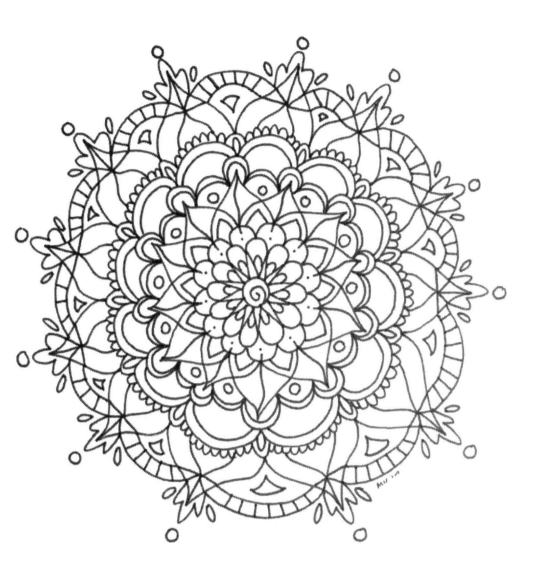

This world would be a whole lot better if we just made an effort to be less horrible to one another.
 -Ellen Page

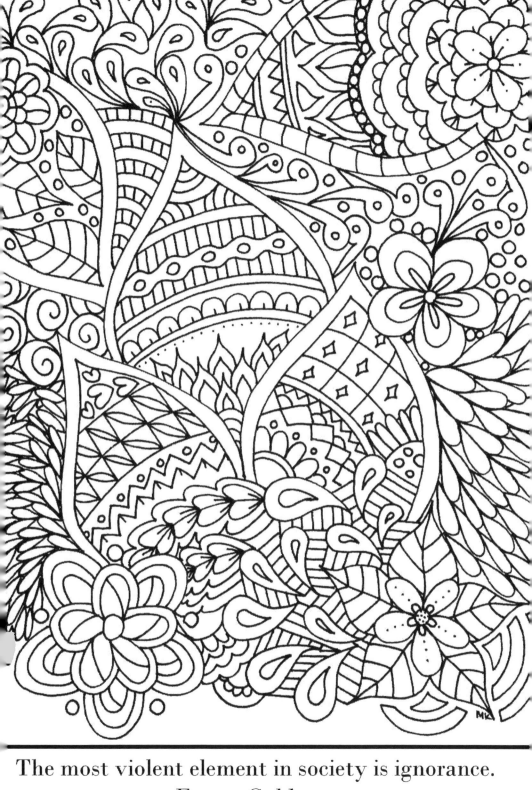

The most violent element in society is ignorance.
-Emma Goldman

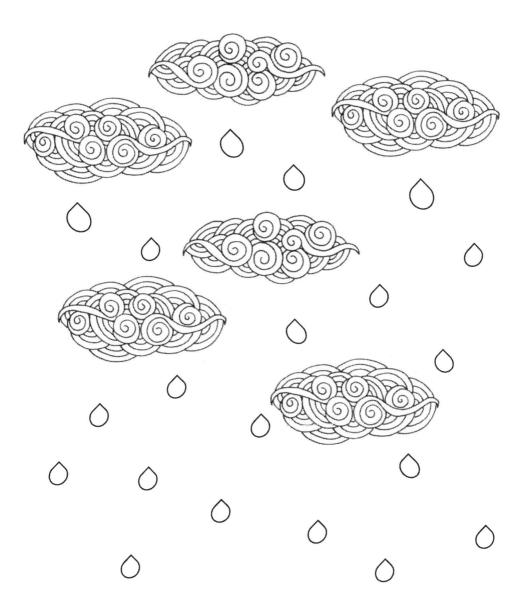

It always seemed to me a bit pointless
to disapprove of homosexuality. It's like
disapproving of rain.

-Francis Maude

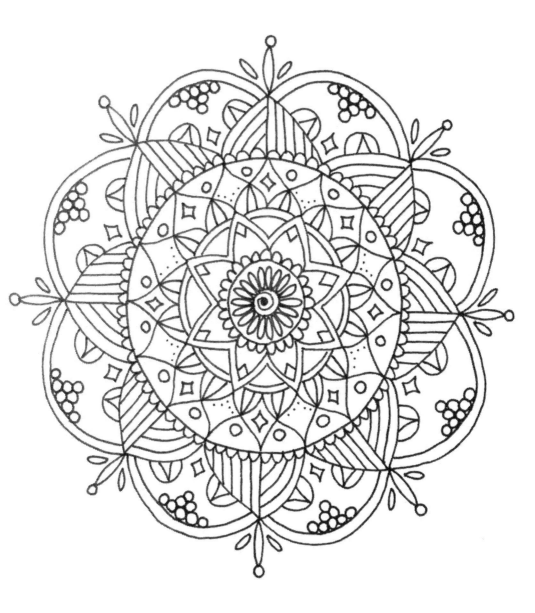

There will not be a magic day when we wake up and it's now okay to express ourselves publicly. We make that day by doing things publicly until it's simply the way things are.

-Senator Tammy Baldwin

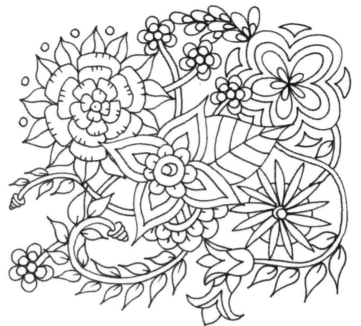

No one can make you
feel inferior
without your consent.
–Eleanor Roosevelt

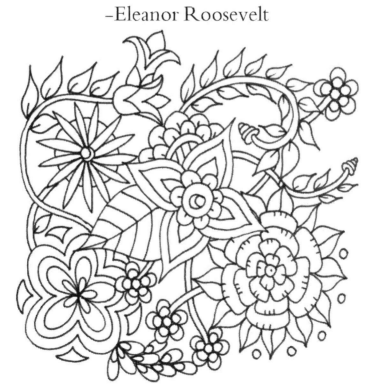

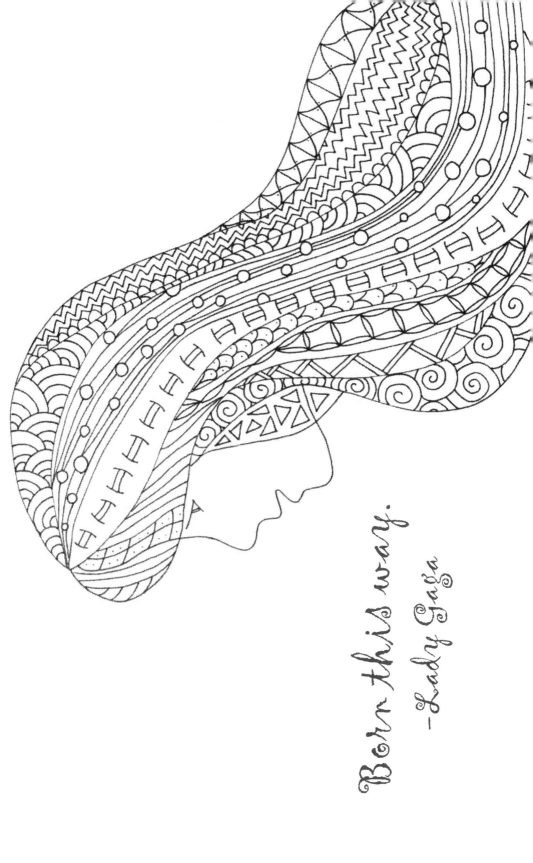

Born this way.

—Lady Gaga

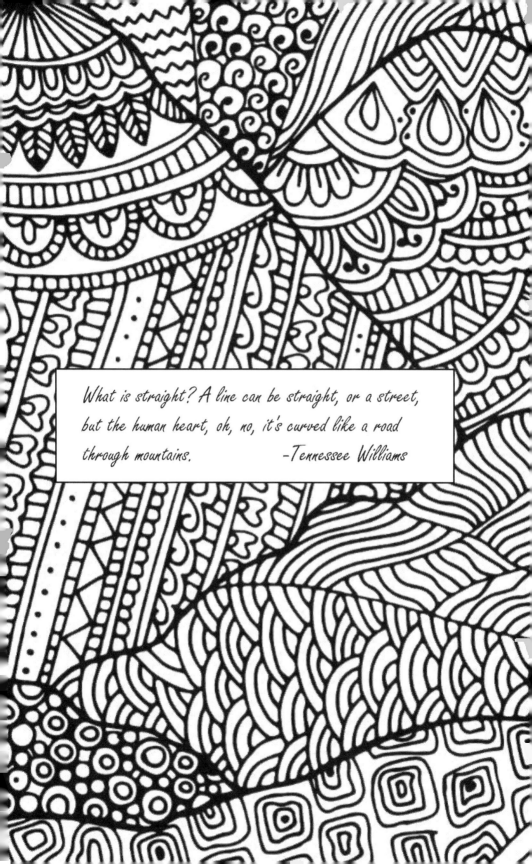

What is straight? A line can be straight, or a street, but the human heart, oh, no, it's curved like a road through mountains.　　　　　　—Tennessee Williams

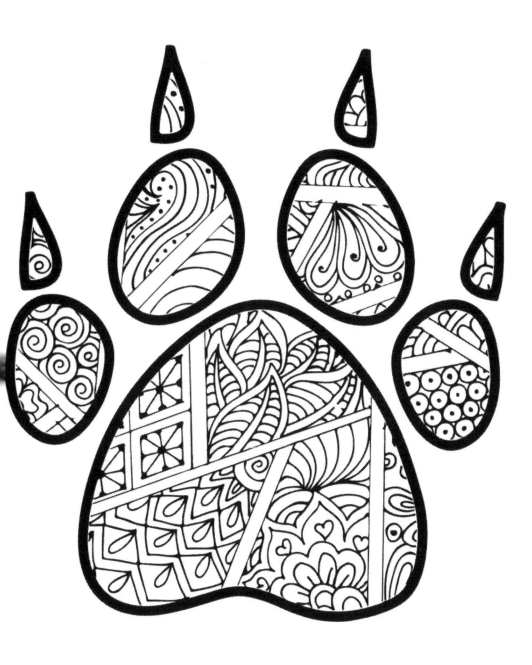

The important thing is not the object of love,
but the emotion itself. -Gore Vidal

When all Americans
are treated as equal,
no matter who they are
or whom they love,
we are all more free.
-Barack Obama

**I think everybody
should like everybody.**

-Andy Warhol

Openness may not completely disarm
prejudice, but it's a good place to start.

-Jason Collins

Gay by birth,
fabulous by choice.
-Birmingham City University LGBT Society

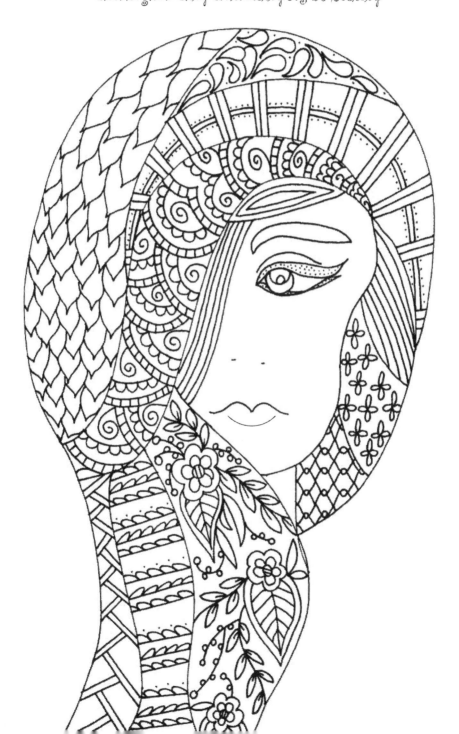

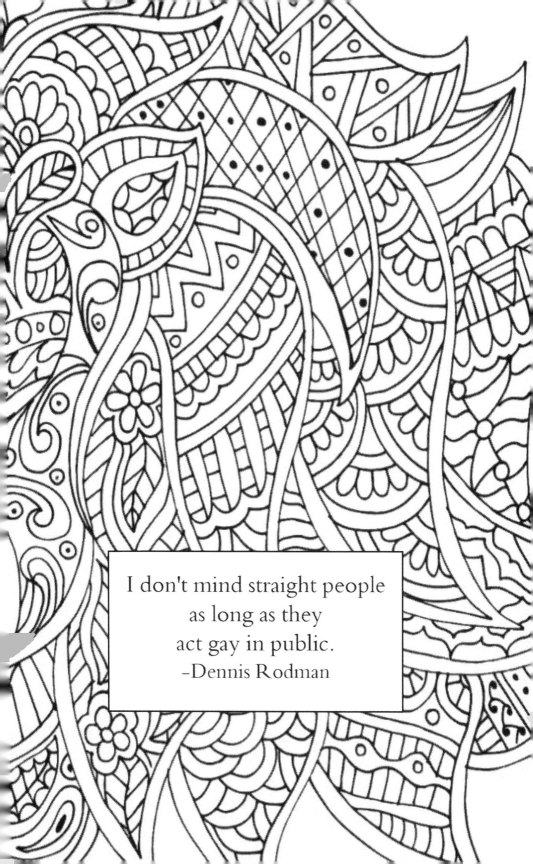

I don't mind straight people
as long as they
act gay in public.
–Dennis Rodman

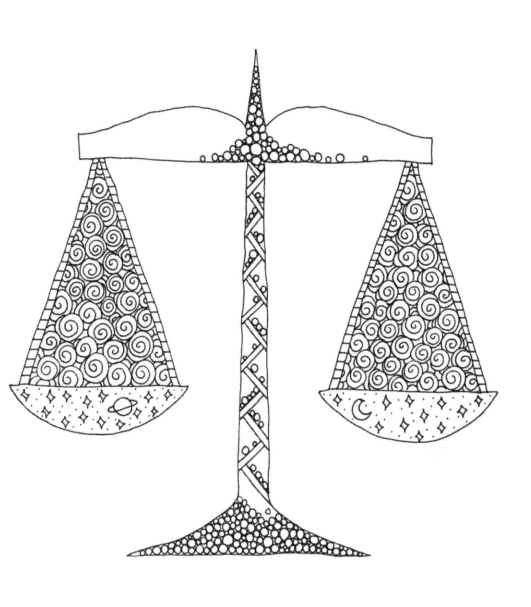

If you want peace, work for justice.
-Pope Paul VI

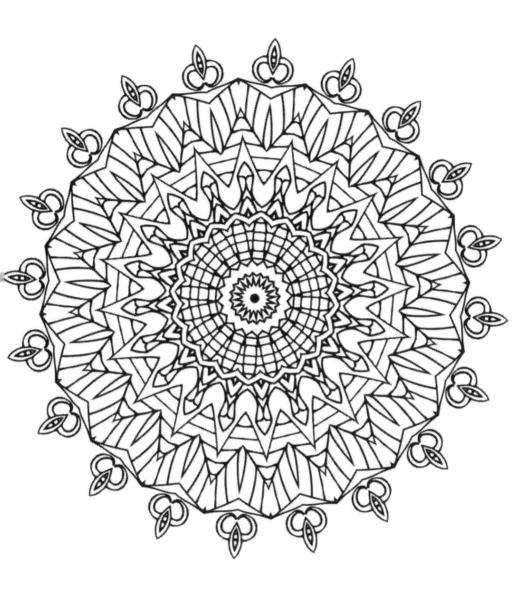

I'm living by example by continuing
on with my career and having a full,
rich life, and I am incidentally gay.
-Portia DeRossi

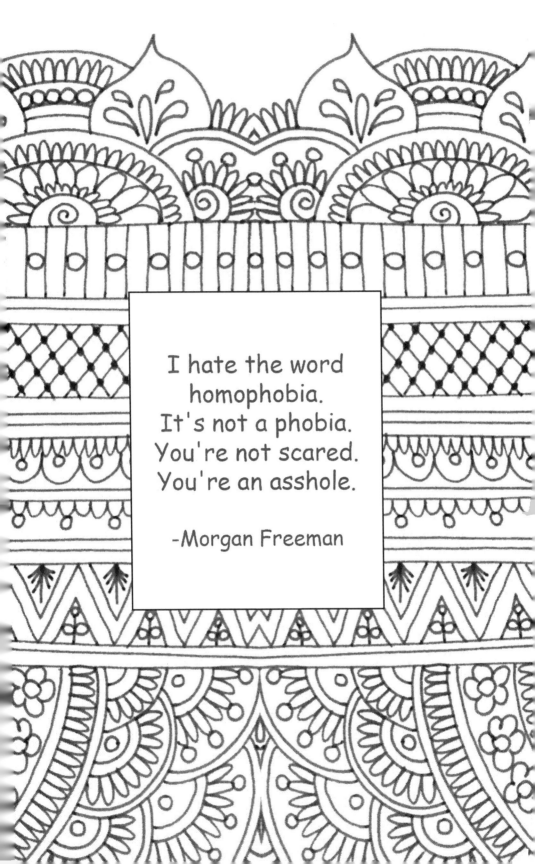

I hate the word
homophobia.
It's not a phobia.
You're not scared.
You're an asshole.

-Morgan Freeman

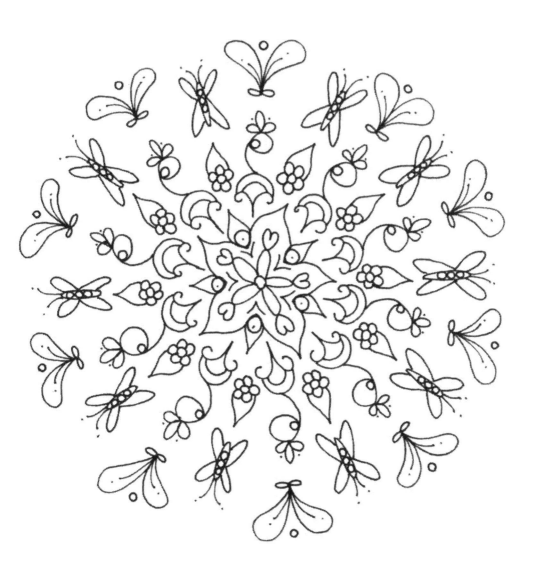

Never be bullied into silence. Never
allow yourself to be made a victim.
Accept no one's definition of your life;
define yourself. -Harvey Fierstein

What do you despise?
By this you are truly known.
–Michelangelo

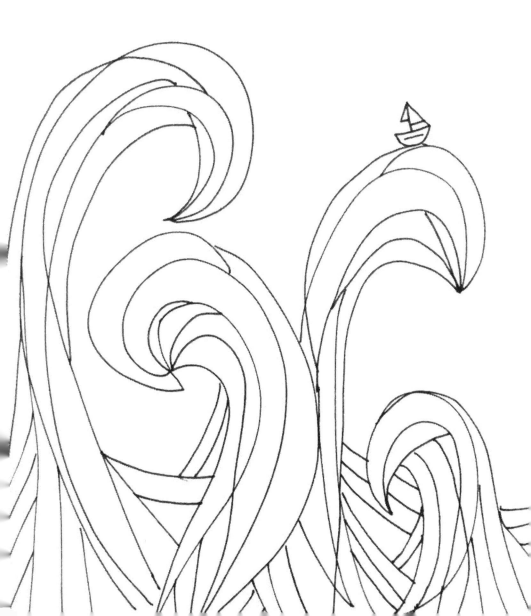

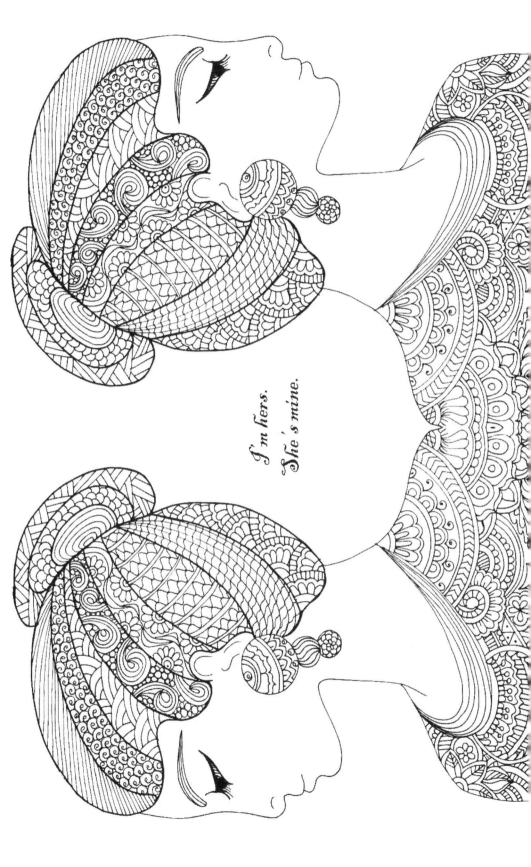

I'm hers.
She's mine.

We should indeed keep calm in the face of difference,

and live our lives in a state of inclusion and wonder

at the diversity of humanity.

-George Takei

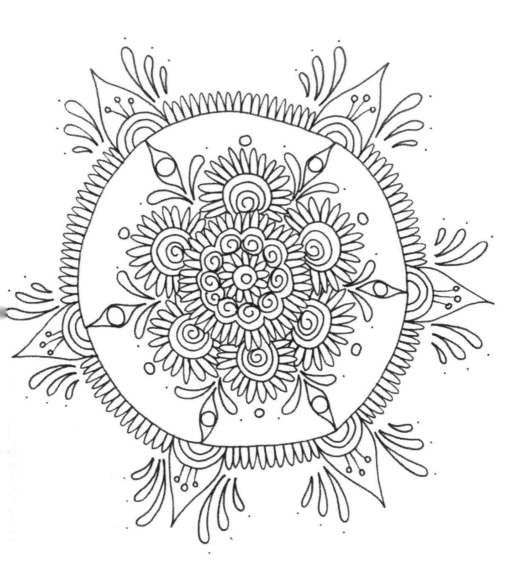

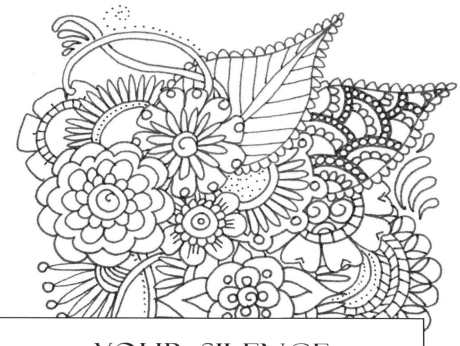

YOUR SILENCE
WILL NOT
PROTECT YOU.

–Audre Lorde

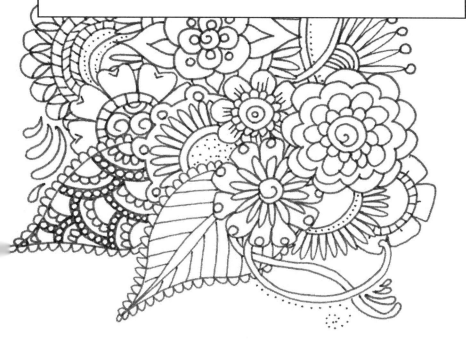

Nobody deserves your tears,
but whoever deserves them
will not make you cry.
–Gabriel Garcia Marquez

Simplicity is the ultimate sophistication.
-Leonardo Da Vinci

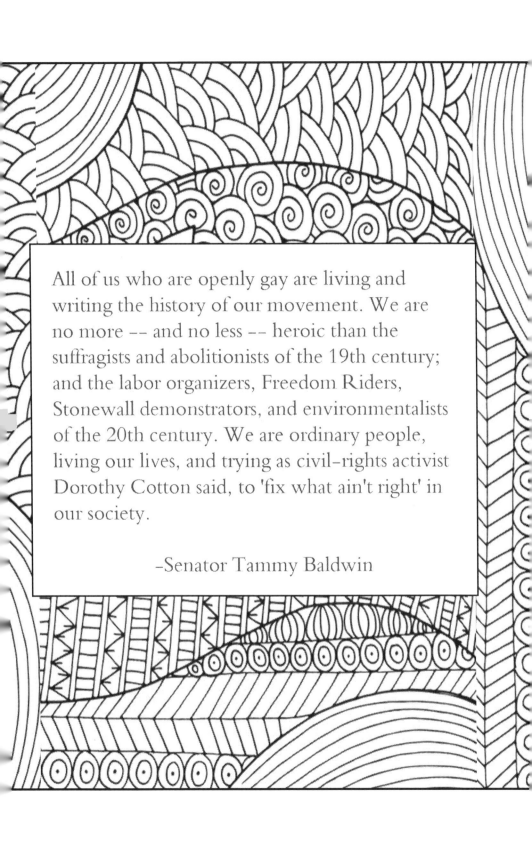

All of us who are openly gay are living and writing the history of our movement. We are no more -- and no less -- heroic than the suffragists and abolitionists of the 19th century; and the labor organizers, Freedom Riders, Stonewall demonstrators, and environmentalists of the 20th century. We are ordinary people, living our lives, and trying as civil-rights activist Dorothy Cotton said, to 'fix what ain't right' in our society.

–Senator Tammy Baldwin

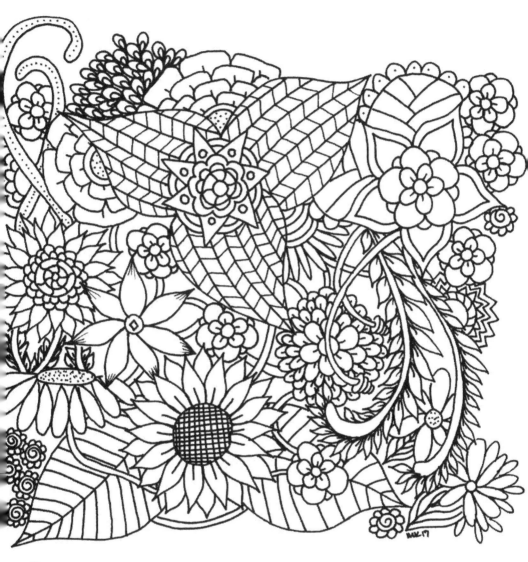

Beauty begins the moment you decide to be yourself.
-Coco Chanel

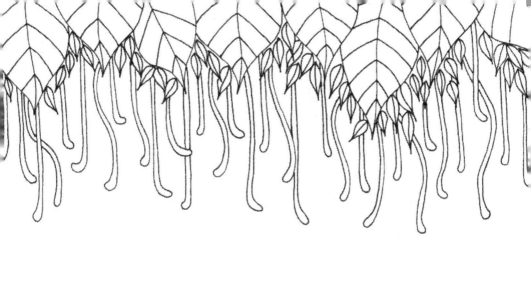

Why is it that, as a culture,

we are more comfortable

seeing two men

holding guns

than holding hands?

−Ernest J. Gaines

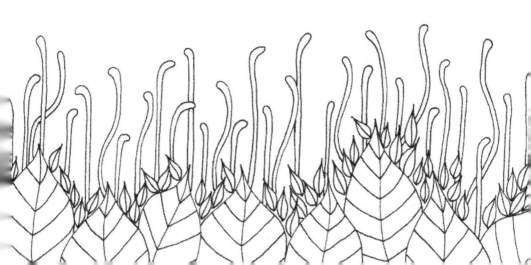

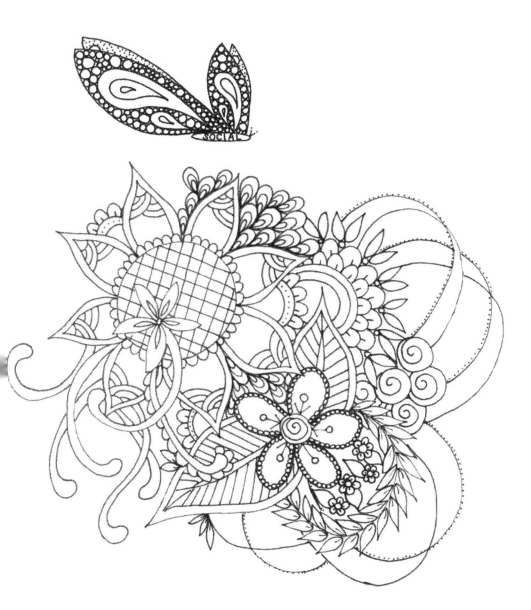

Gay people, we will not win our rights by staying quietly in our closets.... We are coming out to fight the lies, the myths, the distortions. We are coming out to tell the truth about gays, for I am tired of the conspiracy of silence, so I'm going to talk about it. And I want you to talk about it. You must come out. -Harvey Milk

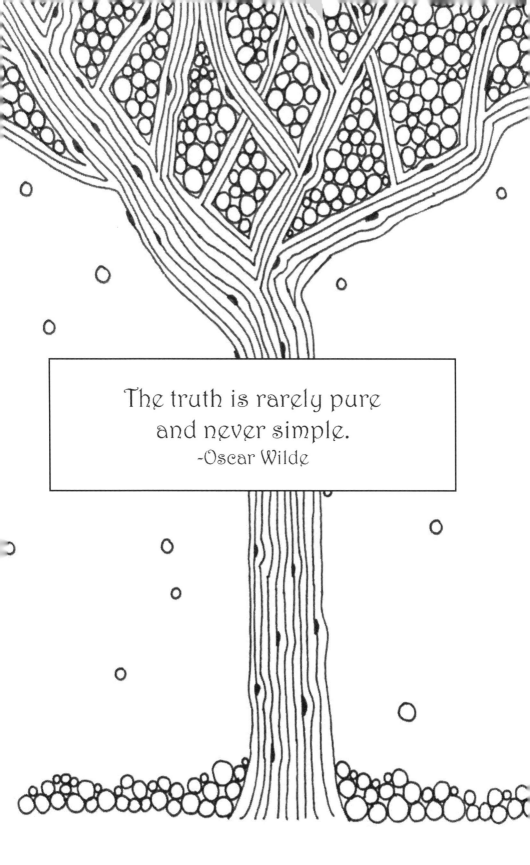

The truth is rarely pure
and never simple.
-Oscar Wilde

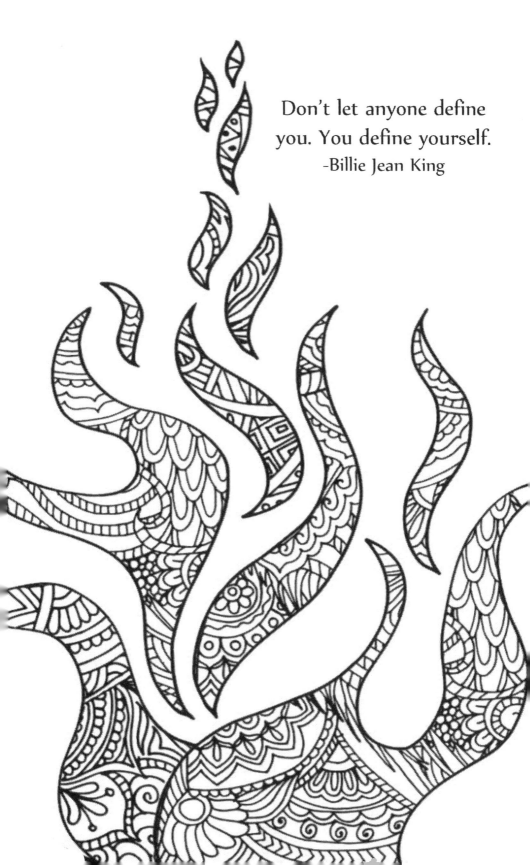

Don't let anyone define you. You define yourself.
-Billie Jean King

It is not in the stars
to hold our destiny
but in ourselves.

-William Shakespeare

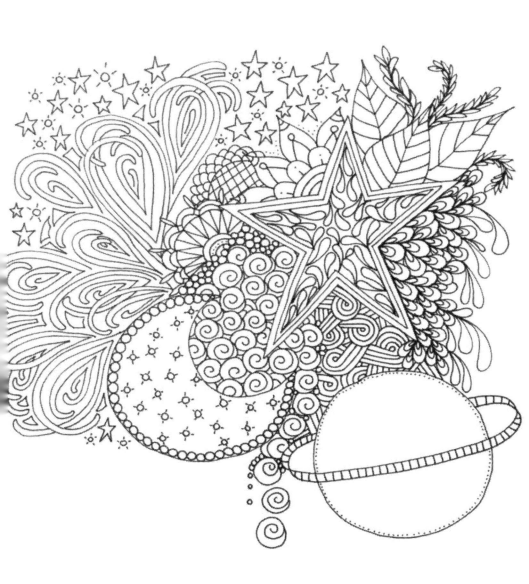

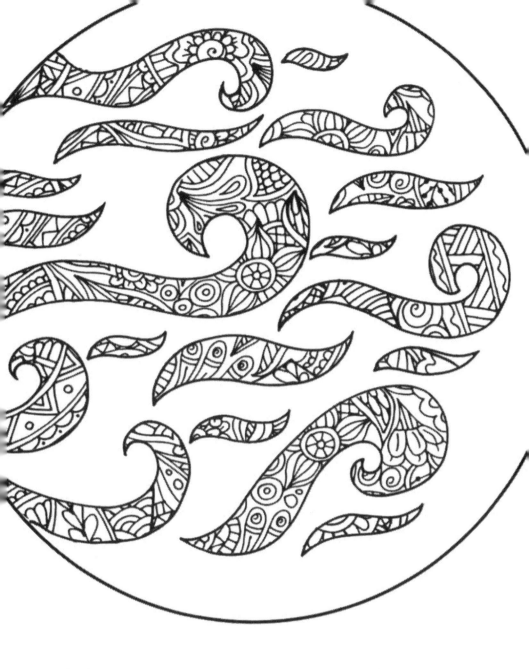

Just by being out you're doing your part. It's like recycling.
You're doing your part for the environment if you recycle;
you're doing your part for the gay movement if you're out.
-Martina Navratilova

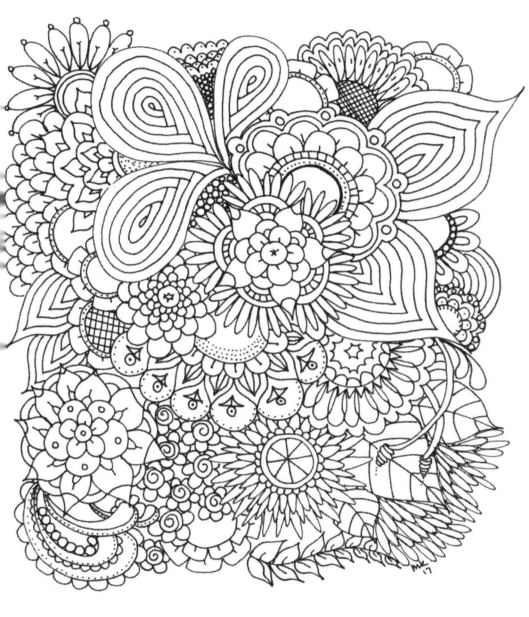

My life, my rules.
-Klaus Wowereit

If homosexuality is a disease, let's all call in queer to work: 'Hello. Can't work today, still queer.
— Robin Tyler

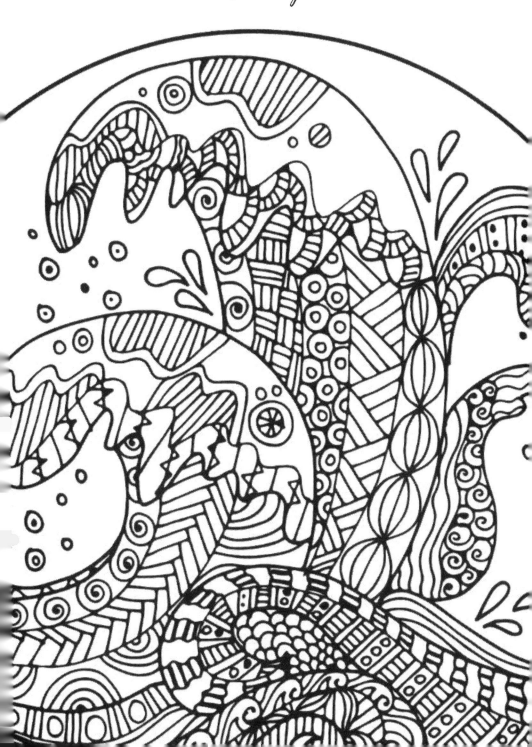

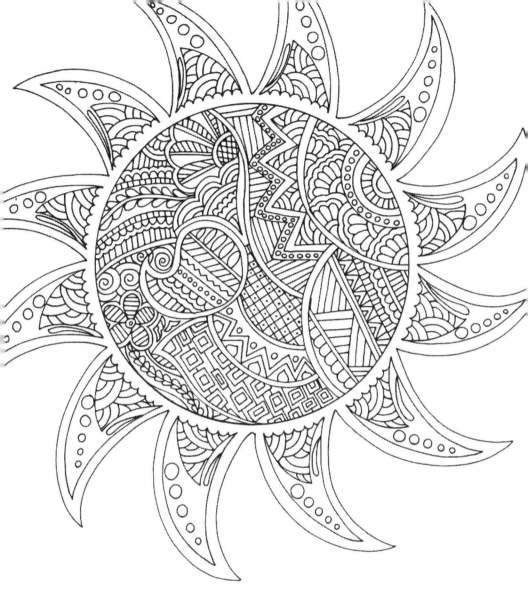

Beginning today, treat everyone you meet as if they were going to be dead by midnight. Extend to them all the care, kindness and understanding you can muster, and do it with no thought of any reward. Your life will never be the same again.

-Og Mandino

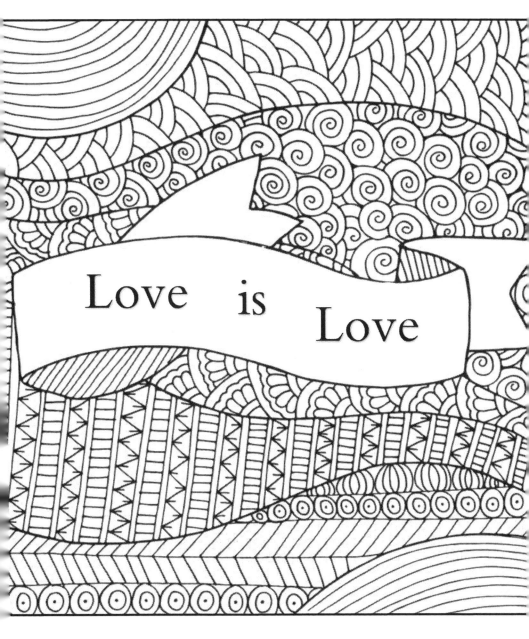

Love is Love

Parker Street Books'
Adult Coloring Books
available on Amazon.

Manufactured by Amazon.ca
Bolton, ON

26763625R00046